GIUSEPPE GABELLONE

MUSEUM OF CONTEMPORARY ART, CHICAGO

GIUSEPPE GABELLONE

CHARTA

DESIGN Studio Rosso, Milano

GRAPHICAL COORDINATION Gabriele Nason

EDITORIAL COORDINATION Emanuela Belloni

EDITING Charles Gute

PRESS OFFICE Silvia Palombi Arte&Mostre, Milano

COVER *Pianta*, detail, 2001

PHOTO CREDITS Page 16: photo by Paolo Pellion, courtesy Castello di Rivoli Museo d'Arte Contemporanea. Pages 13, 32, 33, 34, 35: photos by Studio Blu, courtesy Fondazione Sandretto Re Rebaudengo. Pages 38, 39 and front cover: photos by Studio Blu. Pages 12, 20, 21, 29: photos Roberto Marossi. All images courtesy of the artist and Studio Guenzani, unless otherwise noted below.

© 2002 Edizioni Charta, Milano
© 2002 the Museum of Contemporary Art, Chicago
© Giuseppe Gabellone for his works
© Authors for their texts

All Rights Reserved

ISBN 88-8158-393-3

Library of Congress Control Number: 2002108577

Printed in Italy

Edizioni Charta, via della Moscova, 27 - 20121 Milano ph. +39-026598098/026598200 fax +39-026598577 e-mail: edcharta@tin.it www.chartaartbooks.it

Museum of Contemporary Art, Chicago, 220 East Chicago Avenue, Chicago, Illinois 60611-2604.

This catalogue was published in conjunction with the exhibition *Giuseppe Gabellone* held at the Museum of Contemporary Art, Chicago, September 7, 2002–January 5, 2003.

This exhibition is generously supported by the Exhibition Committee Fund. Additional support is provided by Istituto Italiano di Cultura.

 CONSOLATO GENERALE D'ITALIA
Sezione Culturale
ISTITUTO ITALIANO DI CULTURA

The Museum of Contemporary Art (MCA) is a nonprofit, tax-exempt organization. The MCA's exhibitions, programming, and operations are member supported and privately funded through contributions from individuals, corporations, and foundations. Additional support is provided through the Illinois Arts Council, a state agency; and CityArts Program 4 Grant from the City of Chicago Department of Cultural Affairs. Additional significant support is provided by the State of Illinois. Air transportation services are provided by American Airlines, the official airline of the Museum of Contemporary Art.

Produced by the Publications Department of the Museum of Contemporary Art, Chicago, Hal Kugeler, Director.
Edited by Kari Dahlgren, Associate Director.

LENDERS Studio Guenzani, Milano / Greengrassi, London / Martin Janda, Wien / Luciana Rappo / Dino Zevi

FOREWORD

It is with great pleasure that the Museum of Contemporary Art, Chicago, presents the first exhibition in an American museum of work by Giuseppe Gabellone. In the tradition of Italian artists from the 1960s and 1970s such as Pino Pascali and Mario Merz, Gabellone provokes questions about how art materials convey meaning, reevaluating the properties of photography in particular by laboriously crafting sculptures only to destroy them once he captures their image. By shifting the scale and exploiting the reproductive qualities of photographs, he creates enigmatic and evocative pictures. This project includes five photographs and one large-scale sculpture, highlighting the sophisticated concepts and construction of Gabellone's work. Although he has only been exhibiting for a few years in Europe, the impact of his art has been extraordinary: it was included in the Venice Biennale (1997), the Sydney Biennial (1998), Documenta 11 (2002), and in 2002 Gabellone will be a resident artist at ArtPace in San Antonio, Texas. As the first institution to include one of Gabellone's works in its collection—the MCA acquired Untitled (1999) in 2001—we are delighted to bring his art to a broad audience.

I would like to thank Francesco Bonami, Manilow Senior Curator, who has been following Gabellone's work for years, for bringing this focused group of works to the MCA, and for his illuminating essay in this catalogue. My thanks also go to Julie Rodrigues, Curatorial Assistant, for her commitment to the organization of the show and of the catalogue. We are profoundly grateful for support from the Exhibition Committee Fund – a new MCA initiative to support hallmark projects such as this – and Istituto Italiano di Cultura, Chicago, without whom this project would not have been possible.

ROBERT FITZPATRICK Pritzker Director, Museum of Contemporary Art, Chicago

CONTENTS

Architecture is the first manifestation of man creating his own universe, creating it in the image of nature, submitting to the laws of nature, the laws which govern our own nature, our universe. **LE CORBUSIER**

Form is a mystery, which eludes definition, but makes man feel good in a way quite unlike social aid. **ALVAR AALTO**

...photography does make Nature an impossible concept. **ROBERT SMITHSON**

One of the meanings of the word *baroque* comes from the Portuguese *barocco*, a pearl of irregular shape and unknown origin. In that sense Giuseppe Gabellone's work is baroque, irregular in its appearance and of unknown origin. His working process follows irregular paths through sculpture, architecture, and photography to get to a kind of art that encompasses all three of these disciplines at the same time.

Gabellone was born in Puglia, a southern region of the Italian peninsula where the baroque was a major influence in architecture. Yet Puglia is a sort of anomaly among the southern regions of Italy because of the lasting influence of the northern European Norman invasion, which transformed the baroque into a hybrid, lighter style than it was in Sicily or Naples, where the Spanish influence contributed more heavily. Even in a very unconscious way, Gabellone retains this kind of hybrid baroque in all of his work, constantly subverting the discipline of the style from within. Like the baroque, Gabellone's work is never functional but always symbolic: it forces the viewer into a state of mind between the image and the reality represented.

Gabellone belongs to a generation of Italian artists that was spared the trauma of those who, at the beginning of the 1990s, like children of a divorced couple, had to choose to follow the steps of either the more conservative Transavanguardia movement of the 1980s or the remains of that revolutionary movement called Arte Povera from the late 1960s. Gabellone was young enough to look at history as something still not relevant enough to interfere with the growing pains of his own creative language. Painting and sculpture, along with certain concepts or materials, are just tools to be exploited enough to achieve a specific image or idea; they are not, for Gabellone's generation, ideological areas that demand an oath of honor that will define an artist's lifetime production.

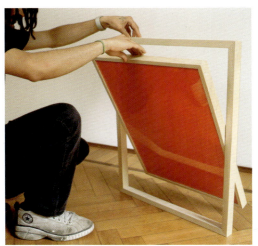

ABOVE

Verde e Arancione, 1998

Wood, acrylic paint on paper, ball bearing, and plexiglas

28 3/4 x 22 13/16 in. (73 x 58 cm)

NEXT PAGE

Exhibition at Fondazione Sandretto Re Rebaudengo per l'Arte,

Guarene d'Alba, 2000

Detail view of the exhibition

Gabellone is a sculptor. Or we could say that he is an artist who is developing an inquiry into the sculptural elements of architecture, photography, and memory, so that the sculpture is not self-contained but refers to how the mind processes memories. When we are in front of Gabellone's sculptures or photographs we are forced to imagine where they come from, what kind of nature generates them and if, in the case of the photographs, whether they really existed somewhere before or if, in our digital age, they are simply the result of some skillful manipulation. In fact all that we see in his works existed in reality at one point or another and was conceived from scratch by the artist's mind and often created with his own labor.

Gabellone seems to refer to Le Corbusier's idea that "the exterior is always an interior," meaning that his images or objects are hiding an inner nature seldom revealed on the surface. His work seems to be the production of a surreal state of mind that sees reality as simply a stage where our desires can find a time to appear as forms and shapes. In this respect Gabellone's work brings to mind the work of the Brazilian architect Oscar Niemeyer. Niemeyer, like Gabellone, fulfilled his quest for organic unity between the individual's creative impulse and his natural

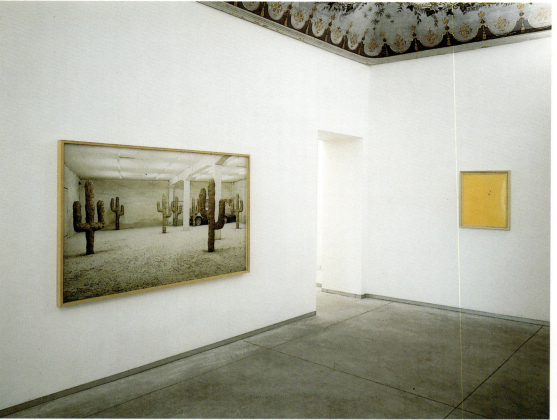

environment through research into expressive forms. In both artists' work, like that of the surrealists, the rational and the irrational are combined in such a way that the preliminary and accurate analysis of the environment, the specificity of the context where the building or the sculpture needs to be realized, is often kept away from the viewer's eye.

Niemeyer found in the Alvorada Palace in Brasília (1958) the basis for his synthesis of the surreal, the classical, and the baroque. In the structure-sculpture built exclusively for the untitled photograph of 1999 (now in the MCA Collection) and then destroyed, Gabellone created the basis for his own synthesis between the surreal, the contemporary, and the baroque, which has become the foundation for most of his work. In order to transform a mere document, the photograph, into an autonomous object, the artist believes that the subject-sculpture of the image needs to disappear

from the world, so that what we will see is the only reality we will be able to absorb. All the labor invested into the making of the structure is the purpose of the final symbolic icon; the goal is, as in Taoist philosophy, the path. The effort is the content of the work, not the volume of its presence. Gabellone pushes the viewer into a metaphysical condition in which he or she can only imagine the existence of the object. In extracting the sculpture from the space and re-creating it in the imagination of the viewer, he erases time from the object and empowers it with a timeless condition. The juxtaposition of the surreal structure with the banality of the space is another way for the artist to enhance the extraordinary and marvelous qualities in his final image.

In an earlier work, the photograph Untitled (1997), we can barely perceive the road through which the artist entered. In this case what we see is not a complex sculpture but a simple table set in an unremarkable industrial environment. Yet the top of the table is a revolving

one and in the image we can see it in an inclined and useless position. Just as in the more complex untitled photograph of 1999 the eye follows the endless curve of the wood to realize that it leads nowhere, in this case the mind follows the top of the table rotating from one position to the other to realize that the table has been transformed from a functional object into a sculpture, an image, a useless thing. Life and art get separated with a simple transformation of a simple and common object. Gabellone's image is in fact an exercise in awareness. We understand the nature and the function of a common object, like a table, only when we disrupt it. Something familiar can become something completely obscure and absurd.

A third image, Untitled (*Fenicotteri*) *(Flamingos)* (2000), is constructed in such a way that time, space, scale, and content collapse like in some interior of a baroque building in which the distorted space and scale of the architecture creates a sense of displacement for the visitor. Gabellone found in a drawer of his childhood home an old postcard with flamingos. His question in this case was: how could he transform a useless piece of his memory into a work of art? He processed the image into three different kinds of space in order to re-create a process similar

ABOVE

Untitled, 2002

Graphite on paper

16 $^9/_{16}$ x 11 $^{13}/_{16}$ in. (42 x 30 cm)

NEXT PAGE

Untitled, 1999

Graphite on paper

11 $^{13}/_{16}$ x 16 $^9/_{16}$ in. (30 x 42 cm)

to the one we experience when we try to bring back to mind places, images, or people. Memory makes things bigger, so Gabellone enlarged the postcard to the size of a billboard. Once we remember something we try to place it into a space or a context, so he framed the large billboard and constructed a structure to support the image, then placed it in an anonymous industrial yard and then took a picture of it. Finally, he printed the image in a size that was not equal to that of the billboard or the postcard, but rather a hybrid size that frustrated any possible attempt to understand the scale and the nature of the image. In fact any attempt to bring memories back to life clashes with the impossibility of it. What we see then is a memory in space, destined to become another memory. The exoticism of the subject is pure serendipity yet it comes out as a symbolic statement about the way we experience and remember far-away places and events.

A fourth image is maybe the most surreal. Untitled (2002) depicts a light blue Styrofoam flower standing in the middle of another industrial yard on a wooden support. It is a vision like the Niemeyer buildings in Brasília, a successful exercise in artificial beauty that time transforms into disconcerting experiences. The carved flower appears like a Magritte fantasy, yet it contains a kind of anguish that was not present in the surrealist painter's work. Gabellone presents an environment where nature seems to be finally defeated, giving space only to the artificiality of its representation, with Styrofoam flowers and industrial backyards. The flower stands on the ground like the famous Chiesa sull' Autostrada (Church on the Motorway) (1961) by the Italian architect Giovanni Michelucci who, after a period of sheer rationalism, entered into a kind of neoexpressionist structuralism. The green copper roof of the church and its beautiful stones clash with the hardness of the motorway, almost piercing the building. Both motorway and church

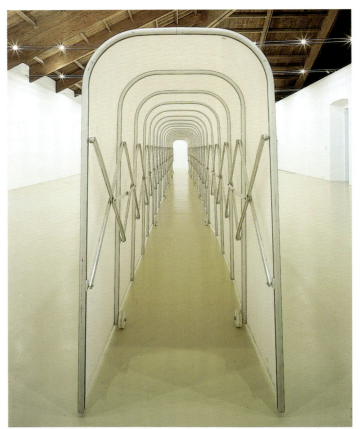

appear artificial next to each other, as much as the flower and the backyard of the factory appear artificial in the image, and yet the image itself is artificial. So what is Gabellone really asking himself and the viewer? Is artificiality part of our contemporary nature, and if so, what is wrong with that? Maybe the answer can be found in Gabellone's major sculpture from 2001.

In *Pianta (Plant)* (2001), a brick wall surrounds a plant. Both the wall and the plant are cast in a green resin, and they appear as if they are growing from the same seed or were petrified at the same time. The image is that of an enchanted garden, with a magic plant at the center. All appears silent, frozen in time. Artificiality here is not the issue because nothing is natural, nothing fights in order to save nature from its destruction. In front of this sculpture we feel that what our mind can make of reality is what really matters, what we can carry with us even when reality disappears, when everything around us becomes artificial and slowly fades away from our life. Memory is what, I believe, Gabellone works with. Yet I do not think it is the kind of memory that has to do with our past, but rather a memory that can in some odd way deal with our future. He thinks about a world yet to

come and how, once forgotten, it will reappear. Who knows in what shape and form? In what material and scale? What matters is not the real but only the soul, the imago, which survives after all has disappeared.

WORKS

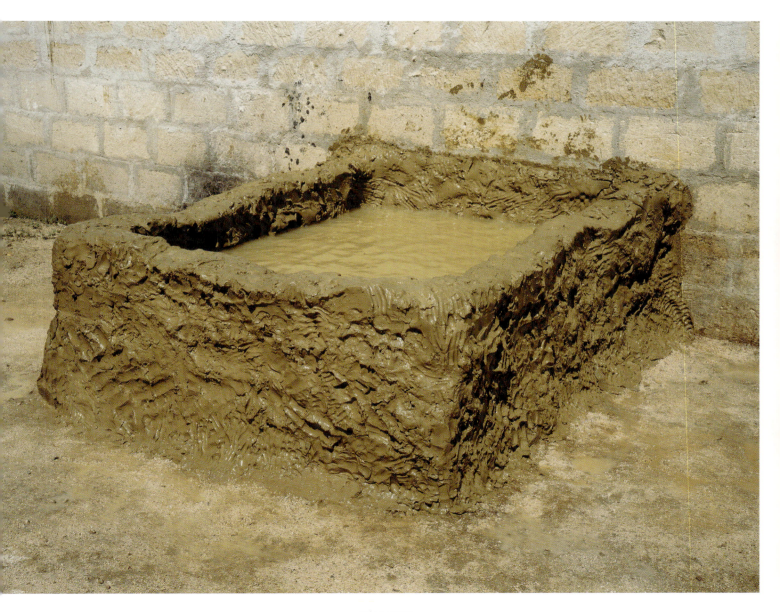

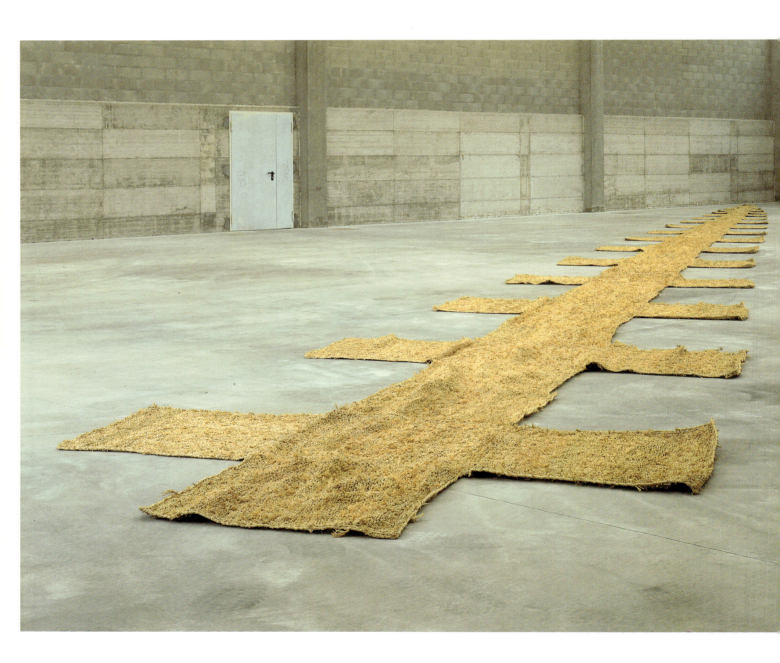

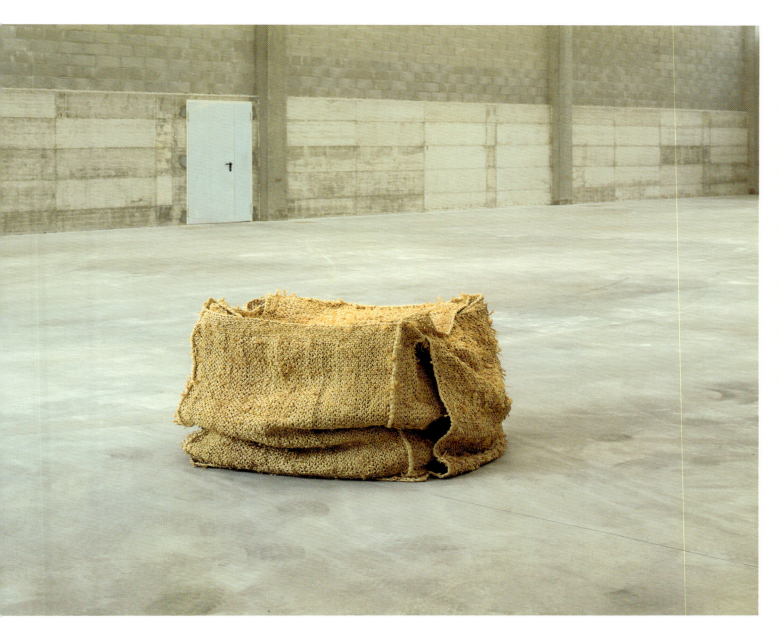

Untitled | 1997

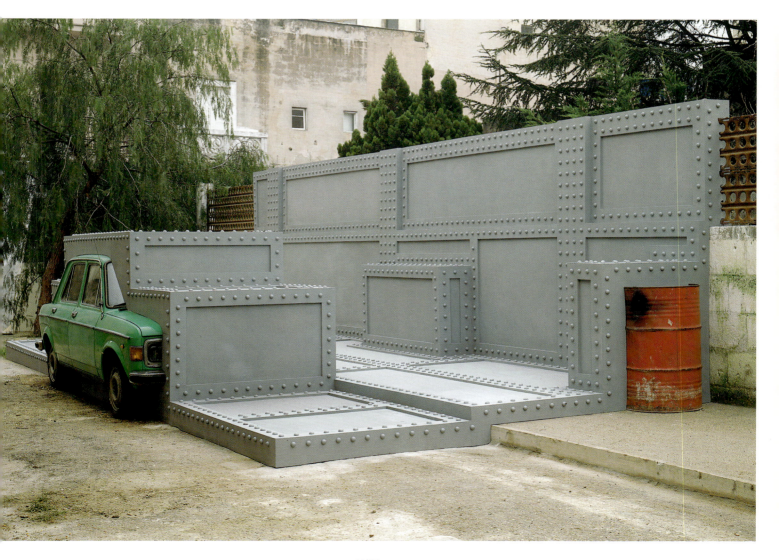

Untitled | 1997

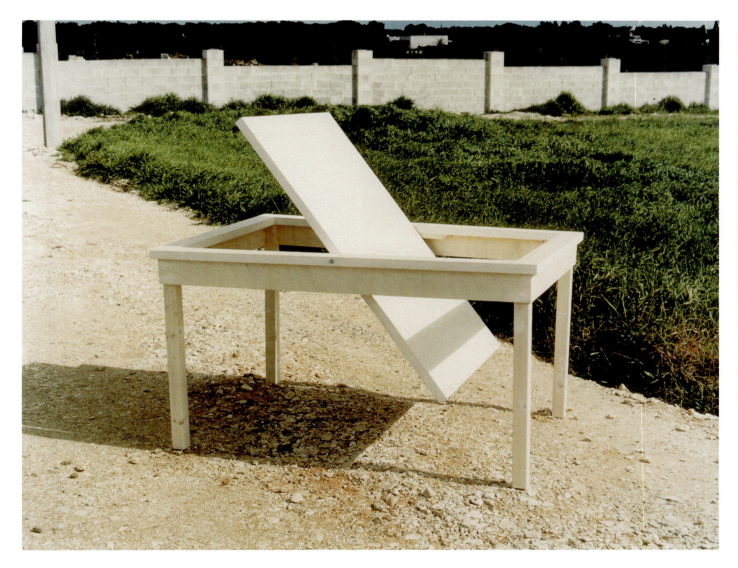

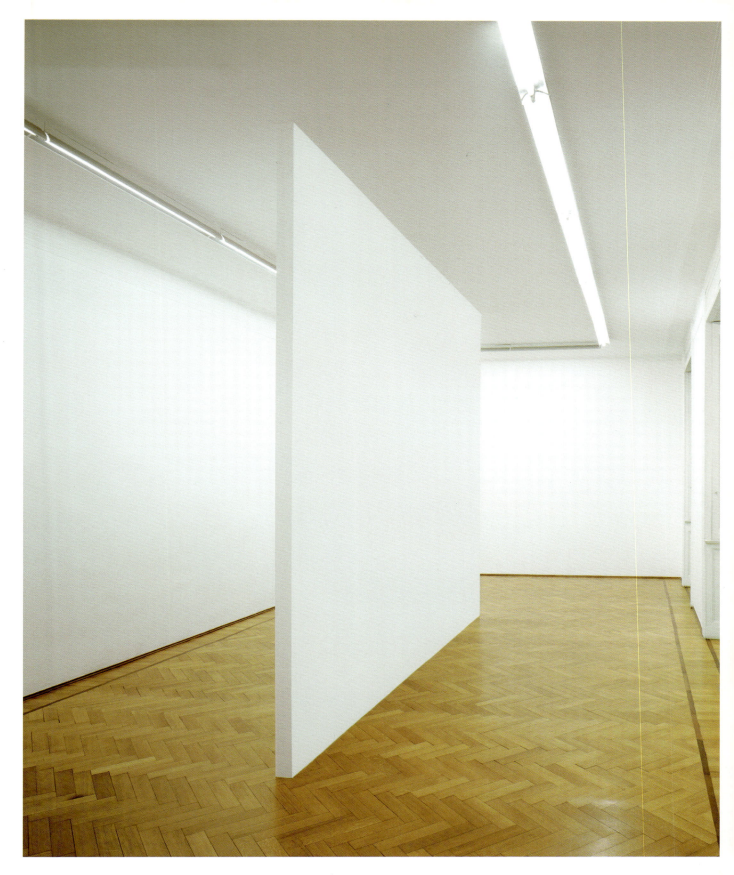

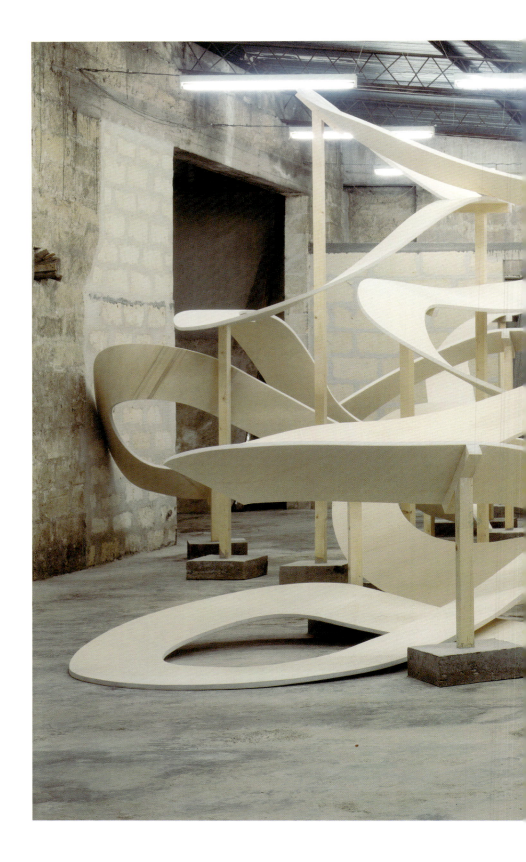

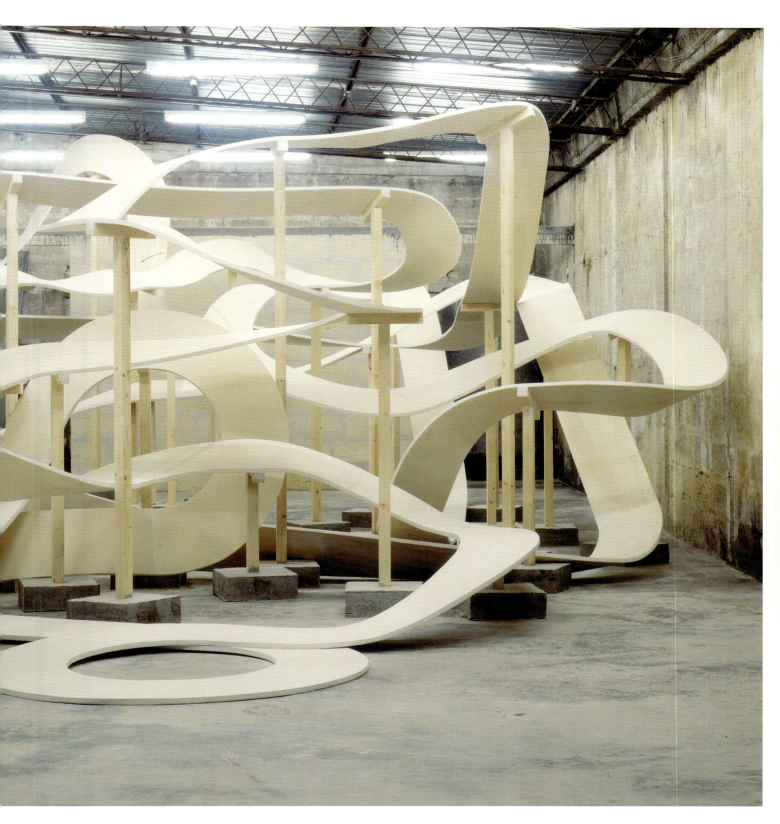

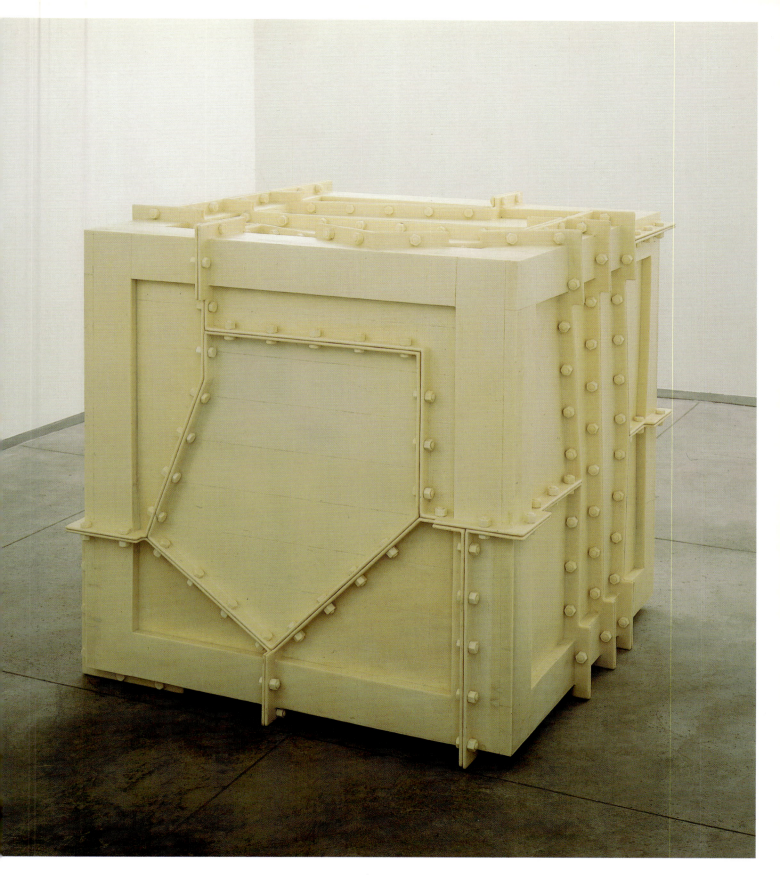

Untitled (Fenicotteri) | 2000

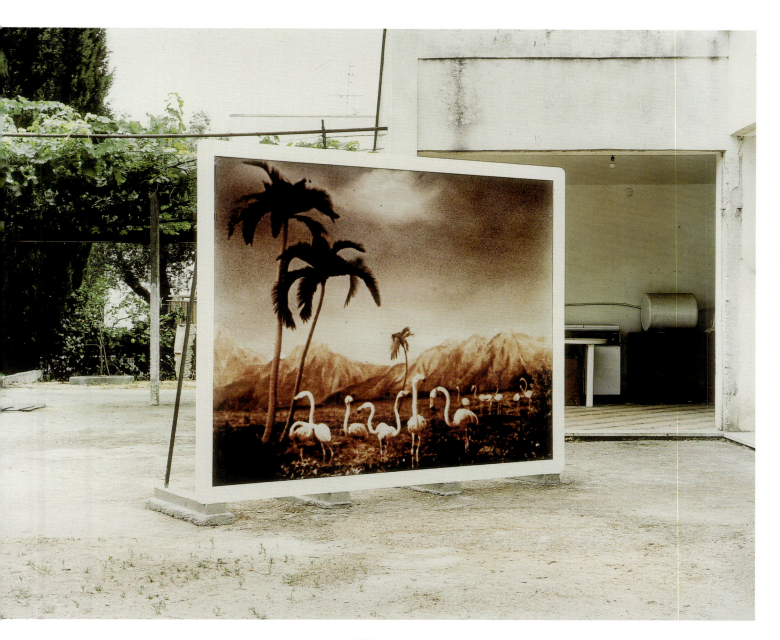

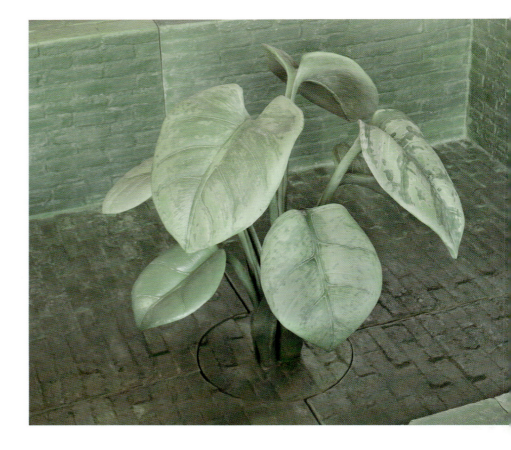

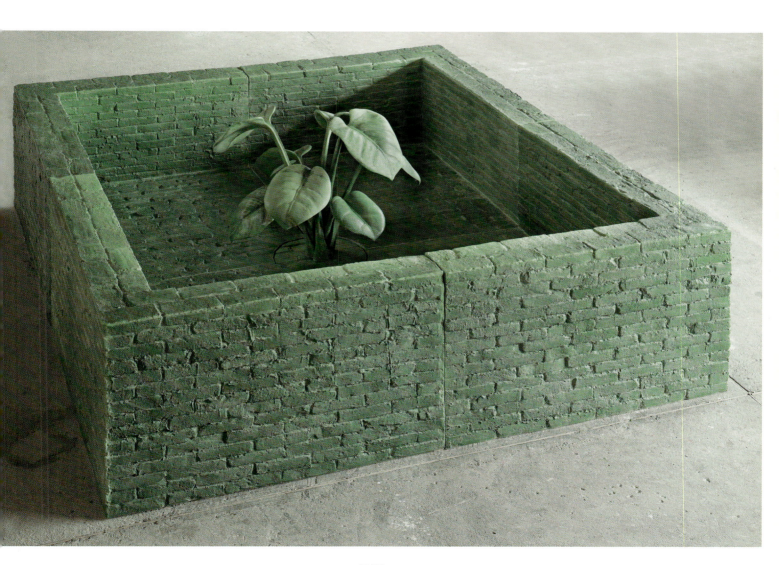

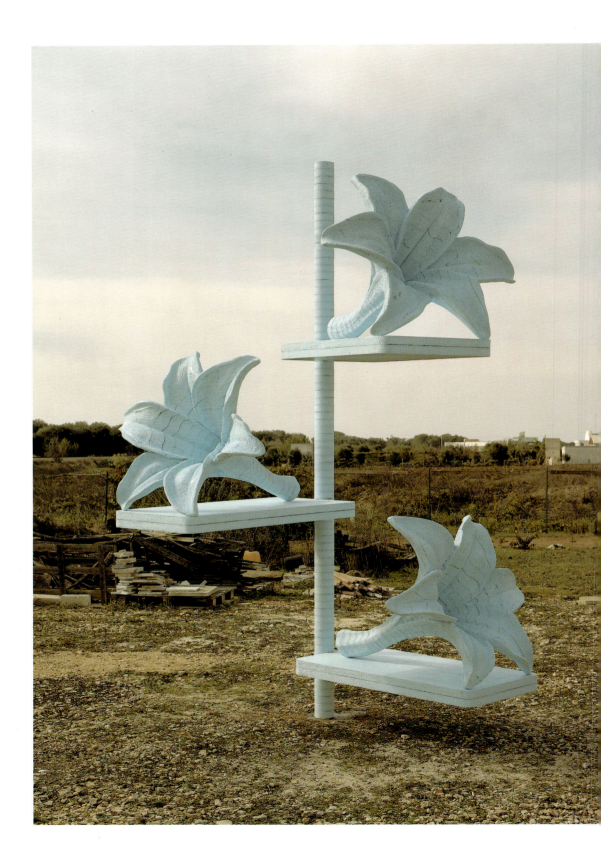

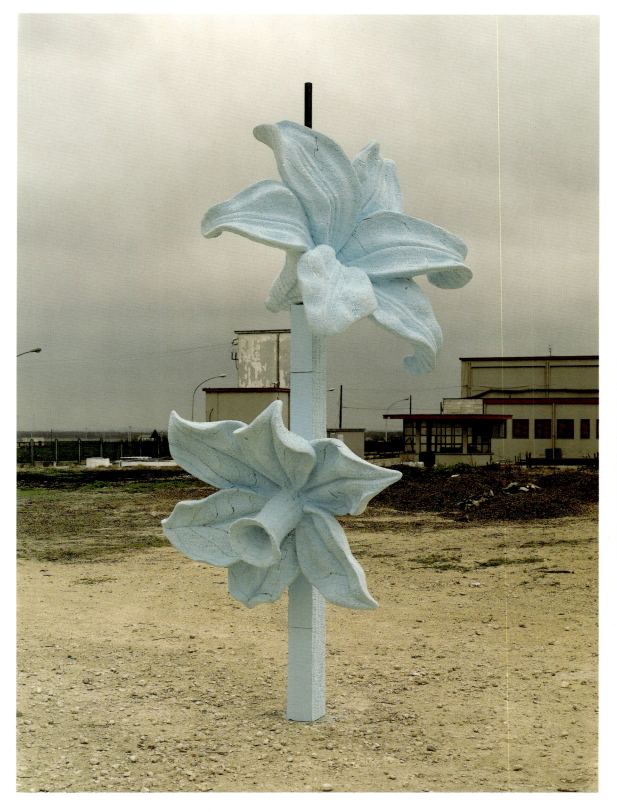

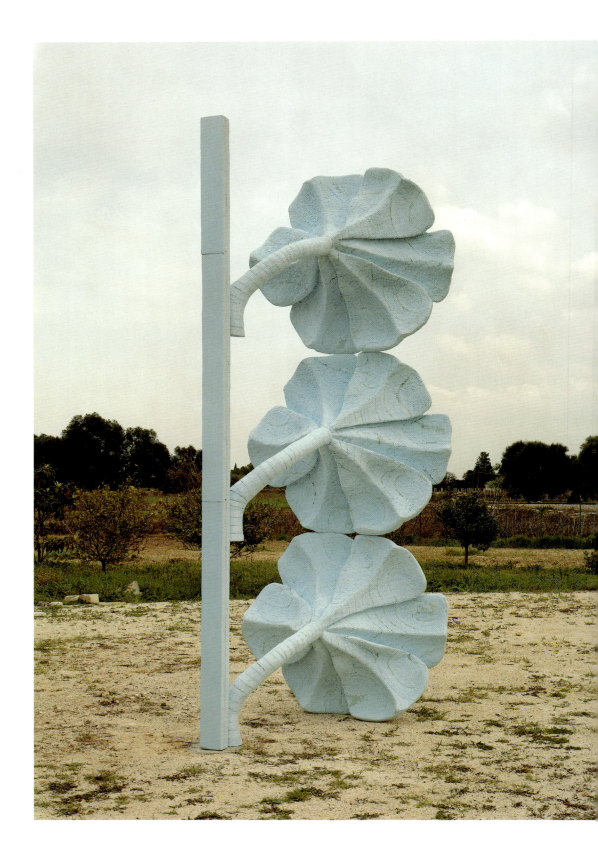

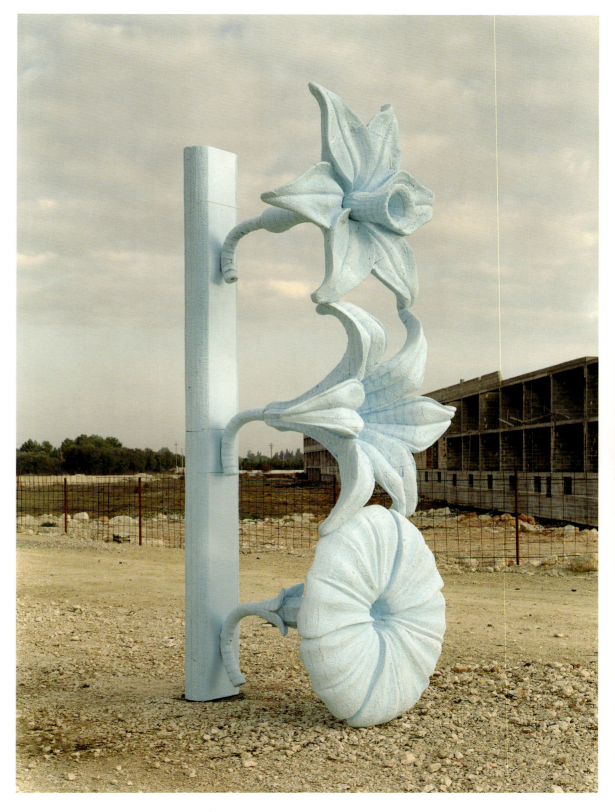

LIST OF WORKS

19		*Vasca*, 1996. Chromogenic development print, 59 1/$_{16}$ x 74 13/$_{16}$ in. (150 x 190 cm)
20	**21**	Untitled, 1996. Raffia, unfolded: 103 3/$_8$ x 9 7/$_8$ ft. (31.5 x 3 m), folded: 3 1/$_4$ x 3 1/$_4$ x 3 1/$_4$ ft. (1 x 1 x 1 m)
23		Untitled, 1997. Chromogenic development print , 59 1/$_{16}$ x 85 7/$_{16}$ in. (150 x 217 cm)
25		Untitled, 1997. Chromogenic development print, 15 x 18 1/$_2$ in. (38 x 47 cm)
27		*Periodo*, 1997. Chromogenic development print, 82 11/$_{16}$ x 59 1/$_{16}$ in. (210 x 150 cm)
29		Untitled, 1999. Air bricks and plaster, 139 3/$_4$ x 169 5/$_{16}$ x 3 15/$_{16}$ in. (355 x 430 x 10 cm)
30	**31**	Untitled, 1999. Chromogenic development print, 59 1/$_{16}$ x 95 5/$_{16}$ in. (150 x 242 cm)
32	**33**	Untitled, 2000. Polyurethane resin and PVC, 21 5/$_8$ x 21 5/$_8$ x 31 1/$_2$ in. (55 x 55 x 80 cm)
34	**35**	Untitled, 2000. Polyurethane resin, 58 11/$_{16}$ x 58 11/$_{16}$ x 58 11/$_{16}$ in. (149 x 149 x 149 cm)
37		Untitled (*Fenicotteri*), 2000. Chromogenic development print, 24 13/$_{16.8}$ x 31 11/$_{16}$ in. (63 x 80.5 cm)
38	**39**	*Pianta*, 2001. Polyurethane resin, 47 5/$_8$ x 112 3/$_{16}$ x 129 1/$_8$ in. (121 x 285 x 328 cm)
40		Untitled, 2002. Chromogenic development print, 82 11/$_{16}$ x 59 1/$_{16}$ in. (210 x 150 cm)
41		Untitled, 2002. Chromogenic development print, 82 11/$_{16}$ x 59 1/$_{16}$ in. (210 x 150 cm)
42		Untitled, 2002. Chromogenic development print, 82 11/$_{16}$ x 59 1/$_{16}$ in. (210 x 150 cm)
43		Untitled, 2002. Chromogenic development print, 82 11/$_{16}$ x 59 1/$_{16}$ in. (210 x 150 cm)

GIUSEPPE GABELLONE Born in Brindisi, Italy, in 1973. Lives and works in Milan.

SELECTED SOLO EXHIBITIONS

2001 Galerie Martin Janda Raum Aktueller Kunst, Vienna, November 21–December 15

2000 Fondazione Sandretto Re Rebaudengo per l'Arte, Guarene d'Alba, September 30–November 19

 Greengrassi, London, January 19–March 18

1999 Frac Limousin, Limoges, France, December 9, 1999–February 26, 2000*

 Studio Guenzani, Milan, February 3–March 19

1998 *Giuseppe Gabellone e Kcho*, Studio Guenzani, Milan, June 8–July 30

1997 Laure Genillard, London, April 11–May 17

1996 Studio Guenzani, Milan, June 6–July 20

SELECTED GROUP EXHIBITIONS

2002 Documenta 11, Kassel*

2001 *Azerty un abecedaire autour des collections du Frac Limousin (The collection of Frac Limousin)*,

 Musée National d'Art Moderne, Centre Georges Pompidou, Paris *

 Chain of Visions, curated by Francesco Bonami, Hara Museum, Tokyo*

 Dinamiche della Vita e dell'Arte, curated by Giacinto Di Pietrantonio, Galleria d'Arte Moderna e Contemporanea, Bergamo

 Squatters, curated by Vicente Todolì, Museu Serralves, Oporto; and Bartomeu Marì, Witte de With Center for Contemporary Art, Rotterdam*

2000 *Future Identities: Reflections from a Collection*, Fondazione Sandretto Re Rebaudengo per l'Arte, Sala del Canal de Isabel II, Madrid *

 La jeune scène artistique italienne dans la collection de la Fondation Sandretto Re Rebaudengo per l'Arte,

 Domaine de Kerguehennec Centre d'Art Contemporain, Centre Culturelle de Rencontre, Bignan

 Over the Edges, curated by Jan Hoet and Giacinto Di Pietrantonio, Stedelijk Museum voor Aktuele Kunst, Ghent *

 Quotidiana, Castello di Rivoli Museo di Arte Contemporanea, Rivoli *

1998 *Every day,* XI Sydney Biennale, curated by Jonathan Watkins, Sydney*

 Mostrato. Fuori Uso 98, curated by Giacinto Di Pietrantonio, Mercati Ortofrutticoli, Pescara*

1997 *Che cosa sono le nuvole?*, curated by Francesco Bonami, Fondazione Sandretto Re Rebaudengo per l'Arte, Guarene d'Alba*

 Delta, curated by Francesco Bonami, Musée d'Art Moderne de la Ville de Paris, Paris*

 Futuro, Presente, Passato, XLVII Biennale di Venezia, curated by Germano Celant, Corderie dell'Arsenale, Venice*

 Odisseo/Odisseus, curated by Giacinto Di Pietrantonio, Stadio della Vittoria, Bari *

 Truce: Echoes of Art in an Age of Endless Conclusions, curated by Francesco Bonami, Site Santa Fe Biennial, Santa Fe, New Mexico*

 Vertical Time, curated by Francesco Bonami, Barbara Gladstone Gallery, New York

1996 *Campo 6. Il Villaggio a Spirale*, curated by Francesco Bonami, Galleria Civica d'Arte Moderna, Turin and Bonnefanten Museum, Maastricht*

 Push-Ups, curated by Emily Tsingou, Athens Fine Arts School, Athens*

1995 *Anni '90. Arte a Milano*, Palazzo delle Stelline, Galleria Credito Valtellinese, Milan*

 Aperto/Italia '95, Trevi Flash Art Museum, Trevi *

 Out of Order, Aperto '95, Galleria Communale d'Arte Moderna, Bologna*

 Transatlantico, curated by Giacinto Di Pietrantonio and Alberto Garutti, Spazio Viafarini, Milan

1994 *VHS*, curated by Giacinto Di Pietrantonio, Palazzina Liberty, Milan

 We Are Moving, curated by Roberto Daolio and Alberto Garutti, Spazio Viafarini, Milan

* Catalogue

SELECTED BIBLIOGRAPHY (ARTICLES AND REVIEWS)

2002 De Cecco, Emanuela. "Stare Senza, la fotografia come accessorio." *Flash Art Italia*, no. 233 (April–May), pp. 82–85.

Gioni, Massimiliano. "Italia sì, Italia no." *Flash Art Italia*, no. 232 (February–March), pp. 96–98.

2001 Curto, Guido. "Giuseppe Gabellone." *Flash Art Italia*, no. 225 (December–January), pp. 114–115.

Verzotti, Giorgio. "Giuseppe Gabellone." *Artforum*, no. 5 (January), pp. 145–146.

2000 Arnaudet, Didier. "Giuseppe Gabellone." *Artpress*, no. 256.

Cherubini, Laura. "Gabellone, l'Universo in un punto solo." *Ars Nova Mediterranea* (Barcelona/Rome), no. 2, pp. 26–31.

Fanelli, Franco. "Il Silenzio dello Scultore." *Vernissage*, no. 9 (October) (Giornale dell'Arte magazine, Turin), p. 13.

Kerner, Anne. "Giuseppe Gabellone. La sculpture en devenir." *Beaux Arts* (February).

Piguet, Philippe. "Gabellone, la sculpture mentale." *L'OEIL* (February).

Rabottini, Alessandro. "Giuseppe Gabellone. Il Mondo in un Hangar." *Flash Art Italia*, no. 223, pp. 98–99.

1999 Cherubini, Laura. "Alla galleria Guenzani l'esposizione di Giuseppe Gabellone." *Il Giornale* (Milan), February 22.

Di Pietrantonio, Giacinto. "Perché/? (appartiene al futuro)." *Magazzino d'Arte Moderna* (Rome).

Gioni, Massimiliano. "Giuseppe Gabellone." *Flash Art Italia*, no. 215 (April–May), pp. 111–112.

1998 Conti, Tiziana. "Tendenze dell'arte giovane in Italia." *Tema Celeste*, no. 68 (May–June), pp. 61–62.

Costantino, Roberto. "Fuori Uso 1998." *Flash Art Italia*, no. 211 (Summer), p. 100.

Cotter, Holland. "Vertical Time." *New York Times*, January 30.

Mancini, Alessandra. "Kcho. Giuseppe Gabellone." *Flash Art Italia*, no. 212 (October–November), p. 132.

Saltz, Jerry. "Vertical Time." *Time Out* (New York) (February 19–26).

Verzotti, Giorgio. "It's Academic." *Artforum* (summer), pp. 49–52.

1997 Casadio, Mariuccia. "Dismisura." *Vogue Italia*, no. 566 (October), pp. 560–68.

Clemmer, David. "Truce." *Flash Art International*, no. 197 (November–December), p. 108.

Detheridge, Anna. "Strategie per un'arte globale." *Il Sole 24 Ore* (Milan), June 8, p. 30.

Di Pietrantonio, Giacinto. "Giuseppe Gabellone (Conversation)." *Flash Art International*, no. 195 (summer), p. 127.

Ebner, Jörn. "Wer reich ist, hat Geschichte." *Frankfurter Allgemeine Zeitung*, April 26, p. 40.

Guha, Tania. "Giuseppe Gabellone." *Time Out* (London), no. 1394 (May 7–14), p. 51.

Marino, Antonella. "Odisseo." *Flash Art Italia*, no. 205 (summer), p. 122.

Zapp Magazine, video no. 9 (March).

1996 Di Costa, Giovanna. "Kcho, Gabellone." *Flash Art Italia*, no. 200 (October–November), p. 97.

Di Pietrantonio, Giacinto. "Giuseppe Gabellone (interview)." *Flash Art Italia*, no. 200 (October–November), pp. 88–89.

Pasini, Francesca. "Allo Studio Guenzani di Milano i cactus di Giuseppe Gabellone." *Liberazione* (Rome), July 5, p. 25.

1995 Budney, Jen. "Aperto." *Flash Art Italia*, no. 193 (summer); *Flash Art International*, no. 184 (October), p. 51.

Kontova, Helena. "Uno, cento, mille Aperto." *Flash Art Italia*, no. 192 (June–July), pp. 61–63.

Somaini, Chiara. "Milano all'opera." *Il Sole 24 Ore* (Milan), April 2, p. 33

BOOKS

2000 *Espresso, arte oggi in Italia*. Milan: Electa.

1999 Bonami, Francesco and Frédéric Paul. *Giuseppe Gabellone*. Limoges, France: Fonds Régional d'Art Contemporain du Limousin; and Turin: Fondazione Sandretto Re Rebaudengo per l'Arte, Guarene d'Alba.

1998 *Cream*. London: Phaidon.

1996 Bonami, Francesco. *Echoes*. New York: Monacelli.

Printed in Italy by Leva spa, Sesto San Giovanni in July 2002 for Edizioni Charta